da Vinci

Gerhard Gruitrooy

NELSON REGENCY
A Division of Thomas Nelson, Inc.

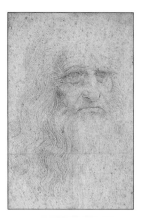

SELF PORTRAIT
CIRCA 1512–1515, RED CHALK,
13 ⅛″ × 8 ⅜″ (33.3 × 21.2CM),
ROYAL LIBRARY, TURIN

INTRODUCTION

One of the greatest artists who ever lived, Leonardo da Vinci was certainly the most versatile genius of the Renaissance. His extraordinary intellectual powers were such that he anticipated many discoveries in science, medicine, and other fields. He came close to explaining the human circulatory system, he designed helicopters and submarines, and he invented the first armored fighting vehicle, but these achievements were all on paper. He left thousands of pages with notes written backwards (possibly to keep his research secret) and hundreds of drawings, but only a few paintings, and still fewer that are completed.

Born in 1452 near the small town of Vinci in Tuscany, Leonardo was the illegitimate son of a Florentine notary. Leonardo was brought up in his

father's house in Florence and eventually trained as a painter in the studio of Andrea del Verrocchio. There he painted his first attributable work, the angel in the *Baptism of Christ*. In 1482 he entered the services of Ludovico Sforza, Duke of Milan, where he was active as court painter, sculptor, military engineer, and architect. Between 1495 and 1498 he executed his famous *Last Supper* in Milan before leaving the city the following year, after it was invaded by the French. By 1500 Leonardo was back in Florence, where he joined Cesare Borgia as a military engineer. He assisted at a number of anatomical dissections, which at that time were still performed largely in secret, and he worked on the *Battle of Anghiari* for the city in competition with Michelangelo's *Battle of Cascina,* neither of which was ever finished. During these years he also painted what was to become an icon of

Western art, the portrait of *Mona Lisa*. Unfortunately, much of Leonardo's work was executed in a peculiar technique that was not lasting. The *Last Supper* in particular has suffered significant deterioration.

In 1508 Leonardo was called to Milan by the French governor of the city. There he was occupied for five years with scientific studies for the construction of a canal. He left Milan for several trips to Florence and Rome. In 1517, at the invitation of King Francis I of France (a great admirer of the artist), he settled with his pupil and assistant, Francesco Melzi, at a castle at Cloux near Amboise. There he pursued his varied interests until he died in 1519. Leonardo was buried in the castle of Cloux.

BAPTISM OF CHRIST
(WITH ANDREA DEL VERROCCHIO)

CIRCA 1470–1472; TEMPERA AND OIL ON
PANEL; 69 ⅝" × 59 ½" (177 × 151 CM);
UFFIZI, FLORENCE

> This panel was begun by Andrea del Verrocchio, in
> whose studio Leonardo worked as an apprentice.
> The panel had probably been left unfinished for
> some time when Leonardo, by then a young
> master in his own right, finished the work by
> adding an angel to the left, changing the character
> of the landscape, and altering the facial expression
> on the figure of Christ.

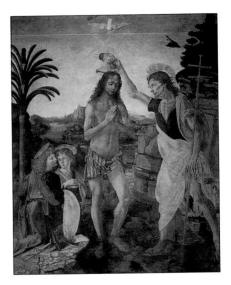

BAPTISM OF CHRIST (DETAIL OF ANGELS)

The most important contribution to the preexisting composition is the addition of the kneeling angel to the left. The angel faces obliquely forward and toward the center, thus witnessing the act of baptism. Leonardo broke with contemporary tradition by turning his angel around in three-quarter view, making him a more eloquent and expressive figure. The angel also concludes the compositional triangle, balancing the figure of St. John the Baptist to the right. The sweet expression on the angel's face and his softly undulating hair foreshadow Leonardo's later stylistic development.

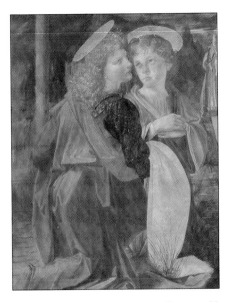

BAPTISM OF CHRIST (DETAIL OF LANDSCAPE)

Leonardo painted the distant landscape in the background over a preexisting one painted by Verrocchio. The young master broke with tradition by portraying nature as a living force. He brought the water forward so that it eddies around Christ's feet, giving the painting a more natural unity. These atmospheric qualities were more clearly developed in later pictures, such as *Annunciation* (page 14).

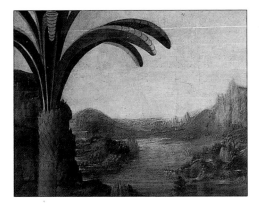

ANNUNCIATION

CIRCA 1473–1475; OIL ON PANEL;
38 ⅛" × 84 ⅛" (96.8 × 213.7CM);
UFFIZI, FLORENCE

As is often the case with Leonardo's paintings, very little is known for certain about the history of this work. It was exhibited publicly for the first time under his name in 1867, when it entered the collection of the Uffizi. Although not executed entirely by Leonardo himself, the overall composition is attributed to him. Collaboration between masters and their assistants was common at that time and was certainly practiced in Verrocchio's studio.

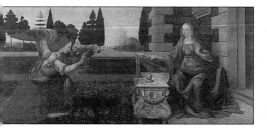

ANNUNCIATION (DETAIL OF ANGEL)

The largest part of this painting is reserved for the angel arriving from the left to offer his angelic greetings to the Virgin, as was traditional when depicting this subject. The angel's head lacks the three-dimensional quality seen in the angel of the earlier *Baptism* (see page 12), a clue that it might have been executed by a studio assistant. The angel is framed by a parapet, which is interrupted to emphasize the head, hand, and lilies. The wings were enlarged at some later time, interfering with the landscape in the back.

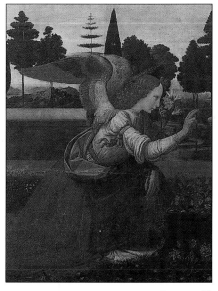

ANNUNCIATION (DETAIL OF LANDSCAPE)

The landscape in the background is universally accepted as being entirely Leonardo's own contribution. Here, he has achieved a smoky atmospheric quality by blurring and softening the natural forms in a technique known as *sfumato* (an Italian word with the figurative meaning "gone up in smoke"). Two cypress trees frame the outlook onto a ragged, crystalline mountain region beyond a body of water dotted with sailing ships. By leaving the execution of the figures to his assistants and retaining the landscape for himself, Leonardo reversed the traditional workshop division.

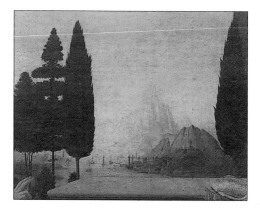

Portrait of Ginevra de' Benci

CIRCA 1475–1476; OIL ON PANEL;
15 1/4" × 14 1/2" (36.2 × 36.8CM);
NATIONAL GALLERY OF ART, WASHINGTON,
D.C.; AILSA MELLON BRUCE FUND

The biographer Giorgio Vasari states that Leonardo painted a portrait of Ginevra de' Benci, daughter of his friend Amerigo di Giovanni Benci. This portrait, formerly in the collection of the Prince of Liechtenstein, has long been regarded as that of the young woman. The identification of the sitter depends on the juniper tree in the background and the juniper twig on the back of the panel (see page 22). The Italian word for juniper is *ginepro* and seems to allude to the sitter's name.

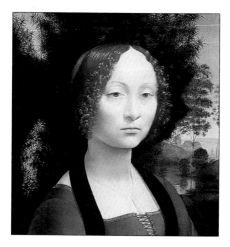

PORTRAIT OF GINEVRA DE' BENCI
(BACK OF PANEL)

The Latin motto *Virtutem forma decorat* (she adorns her virtue with beauty) obviously refers to Ginevra, who belonged to the prominent and wealthy Benci family of Florence. Leonardo's *Adoration of the Magi* (see page 26) belonged for some time to the Bencis. The motif of the wreath of bay and palm has been identified as the personal device of the Venetian ambassador to Florence, Bernardo Bembo. The painting can therefore be interpreted as his offering of devotion to this beautiful young woman, to whom various poets also dedicated sonnets.

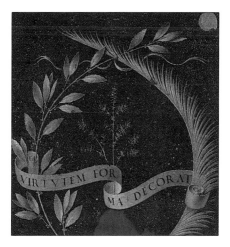

BENOIS MADONNA

CIRCA 1478; OIL ON CANVAS (ORIGINALLY PANEL); 19 $\frac{1}{2}$" × 12 $\frac{3}{8}$" (48.75 × 30.9CM); HERMITAGE, ST. PETERSBURG

Leonardo's authorship of this work is corroborated by the existence of preparatory drawings that are clearly in the artist's hand. This painting, which has retained its unusual freshness and charm over the centuries, shows the Christ Child seated on a pillow supported by the Virgin's legs, revealing a close relationship between the child and his youthful and smiling mother. As warm and natural as the scene appears, a ceremonial and dignified quality appropriate for this religious subject nevertheless prevails. The light comes from the left, not from the window in the back, revealing the forms as three-dimensional.

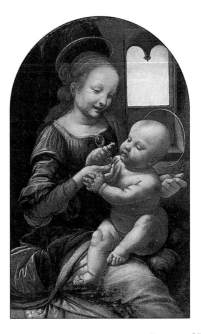

ADORATION OF THE MAGI

CIRCA 1481–1482; UNDERPAINTING ON PANEL; 97 1/8" × 95 7/8" (246.7 × 243 CM); UFFIZI, FLORENCE

Begun in 1481 for the monastery of San Donato a Scopeto near Florence, this work was left unfinished when Leonardo departed for Milan in 1483. Though it is little more than a monochromatic drawing, this painting nonetheless reveals the artist's ability to redefine a traditional subject and fully exploit its content. The centralized semicircular composition shows the Madonna and Christ Child being worshiped by the Magi. The background contains a group of soldiers engaged in combat (probably allegorical) and an extraordinary architectural ruin (see page 28).

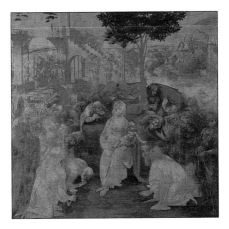

PERSPECTIVE DRAWING FOR THE ADORATION OF THE MAGI

1481–1482; PEN AND INK AND WASH OVER METALPOINT; 6 ½" × 11 ½" (16.5 × 29.2 CM); GABINETTO DISEGNI E STAMPE, UFFIZI, FLORENCE

The architectural motif of the courtyard of a ruined palace was partially used in the background of the *Adoration of the Magi,* also in the Uffizi (see page 26). The wall on the left with the double staircase is drawn in admirable perspective. Its scientific precision appears to be contradicted by the ghostlike invasion of horses and agitated figures, while the exotic presence of a camel resting before the staircase adds to the confusion.

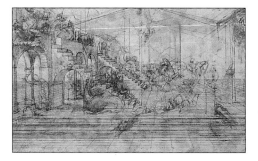

St. Jerome

CIRCA 1482; UNDERPAINTING ON PANEL;
40 5/8″ × 29 1/2″ (103.3 × 74.9CM);
PINACOTECA, VATICAN

The ascetic St. Jerome, striking himself in penitence, is seen in the wilderness of a desert; the lion, his symbol, is stretched out in front of him. The early history of this unfinished painting remains a mystery. At one time it was owned by the Swiss artist Angelica Kauffmann. Eventually, it was cut in two pieces and damaged in various other ways. Joseph Cardinal Fesch, uncle of Napoleon Bonaparte, is said to have miraculously brought both parts together and arranged for the painting to be restored. It was bought from the cardinal's heirs by Pope Pius IX (1846–1878) for the Vatican museums.

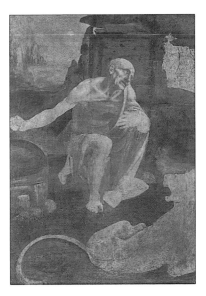

MADONNA OF THE ROCKS

CIRCA 1483–1485; OIL ON CANVAS
(ORIGINALLY PANEL); 78 × 48 ½"
(198.1 × 123.2CM); LOUVRE, PARIS

During his stay in Milan, Leonardo and two Milanese artists, the brothers Ambrogio and Evangelista de' Predis, signed a contract with the Confraternity of the Immaculate Conception to paint a wooden altarpiece consisting of three panels for a chapel in San Francesco Grande. Leonardo executed the central scene of the Madonna and his fellow artists painted the outer panels with two angels. The introspective solemnity of this central scene of the Madonna and Christ Child, the young St. John the Baptist, and an angel is supported by the gentle gradations of ethereal light.

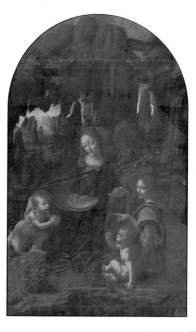

MADONNA OF THE ROCKS (DETAIL OF LANDSCAPE)

Behind the figures a slightly darkened cavern leads into the distance where a misty landscape of rocks and water unfolds. A golden light gently bathes the rough-hewn cliffs. Leonardo's precisely observed and rendered landscape is not merely a self-conscious demonstration of his first-hand experience with Milanese weather conditions. It allows him rather to contrast the more sharply rendered foreground with the mystical panoramic view in the distance. Landscape has thus not merely a decorative function, but becomes an integral part of the overall artistic concept.

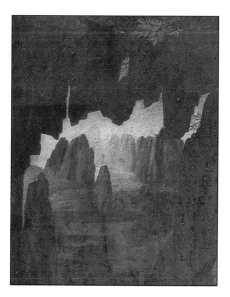

MADONNA OF THE ROCKS
(DETAIL OF CHRIST CHILD AND ANGEL)

The angel, pointing to the infant John the Baptist, is a vivid and candid rendering of a youthful figure similar to the angel in the *Baptism of Christ* (see page 10). The fleshy, round body of the Christ Child, his puffy cheeks, and his right hand raised in a gesture of blessing are Leonardo's interpretation of a popular pose established by contemporary sculptors. The Virgin's foreshortened, hovering hand seems to protect and crown the Christ Child like a halo.

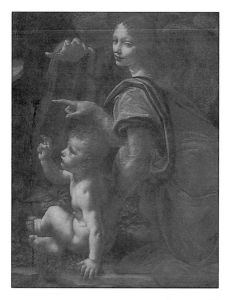

MADONNA OF THE ROCKS

CIRCA 1486–1490 AND 1506–1508;
OIL ON PANEL; 74 ⅝″ × 47 ¼″
(189.6 × 120 CM);
NATIONAL GALLERY, LONDON

This second, almost identical version of the *Madonna of the Rocks* replaced the Louvre painting (see pages 32–37), which Leonardo might have sold to another patron, perhaps Ludovico Sforza of Milan. It lacks some of the sweetness and mystery of the former picture and its varied treatment suggests a prolonged execution. It was on the altar of the chapel until the eighteenth century, while the Louvre picture might have entered the French Royal collections as early as 1499, when Louis XII conquered Milan.

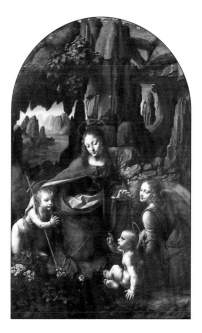

MADONNA OF THE ROCKS (DETAIL OF MADONNA)

It is unusual to find Leonardo repeating himself. In the case of the *Madonna of the Rocks,* however, he was obliged by contract to deliver the commissioned work. Although closely following the first version, the Virgin's face and expression have become more mature and the relationship to the Christ Child has grown more distant. One feels a certain lack of crispness and spontaneity in this figure, which is probably due to the repetition, but may also be due to the intervention of an assistant, possibly Ambrogio de' Predis.

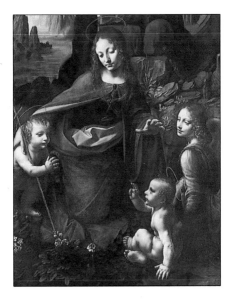

Last Supper

1495–1497; Oil-tempera mixture on wall; 166" × 355 ½" (421.6 × 903 cm); Refectory, Santa Maria delle Grazie, Milan

Next to the *Mona Lisa* (see page 54) the *Last Supper* is Leonardo's most famous work. Since he worked slowly, Leonardo did not use the traditional fresco technique, but instead used a highly personal method involving a mixture of oil paint on dry plaster. This procedure did not prove to be of lasting effect and the painting began to decay during the artist's lifetime. Today we can only guess what impression the once-vivid hues of blue, red, green, and yellow must have made upon the monks of the monastery who could look at this work during their daily meals.

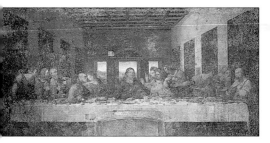

LAST SUPPER (DETAIL OF CHRIST)

The focus of the Last Supper, Christ is at the painting's center where He is seen extending His arms while pronouncing that one of His disciples would betray Him. His left hand is reaching toward a loaf of bread while His right reaches toward a glass of wine, which together symbolize the redemption. Christ is physically and psychologically separated from His disciples, who are in emotional disarray because of the impending betrayal. Christ's head, framed by the window and the landscape behind Him, is the point to which the eye gravitates.

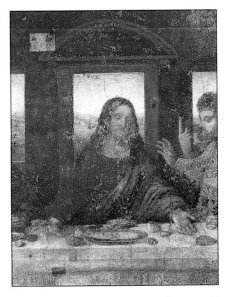

LAST SUPPER (DETAIL OF APOSTLES TO THE RIGHT)

The Apostles who can be individually identified
with some degree of certainty all bear distinct per-
sonal features and reveal a range of reactions to
Christ's pronouncement. In his treatise on painting,
Trattato della Pittura, Leonardo stressed the impor-
tance of creating a variety of characters in a larger
composition in order to avoid repetition. Here we
see signs of dismay, anger, fear, and warning,
among other emotions, in the facial expressions
and bodily gestures of the disciples.

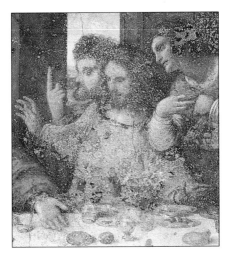

LAST SUPPER (DETAIL OF APOSTLES TO THE LEFT)

Leonardo's achievement in depicting this common subject in a totally new fashion came through hard labor and study. He reportedly would "often come to the convent at early dawn....Hastily mounting the scaffold, he worked diligently until the shades of evening compelled him to cease, never thinking to take food at all, so absorbed was he in his work. At other times he would remain there for three or four days without touching his picture, only coming for a few hours to remain before it, with folded arms, gazing at his figures as if to criticize them himself."

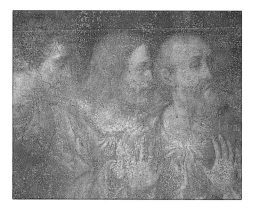

Lady with the Ermine (Cecilia Gallerani)

CIRCA 1490; OIL ON WALNUT PANEL;
21 $\frac{3}{8}$" × 15 $\frac{7}{8}$" (54.3 × 40.3 CM);
CZARTORYSKI MUSEUM, CRACOW

Cecilia Gallerani was a highly educated woman at the court of Milan. While still in her teens, she had briefly been the mistress of the city's ruler, Duke Ludovico Sforza. The ermine on her arm, which is of an unnaturally large scale, is a humanistic pun on her family name—*galee* is the Greek word for ermine—but it is also a well-known symbol of moderation and chastity. Leonardo himself wrote about the animal that "because of its moderation, it only eats once a day" and "the ermine would die rather than soil itself."

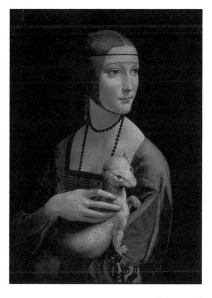

VIRGIN AND CHILD WITH ST. ANNE (BURLINGTON HOUSE CARTOON)

CIRCA 1497–1499; CHARCOAL HEIGHTENED
WITH WHITE ON BROWN PAPER;
54 7/8" × 39 7/8" (139.3 × 101.3 CM);
NATIONAL GALLERY, LONDON

An old tradition dates this cartoon (a large drawing in preparation for a painting) to Leonardo's last years in Milan before his return to Florence in 1500. Considered one of the artist's most beautiful works, the smiling heads of the Virgin and St. Anne, the charming discourse between Christ and St. John the Baptist, and the voluminous rendering of their bodies, as well as the broadly floating folds of the drapery, are of unrivaled harmony. Here, Leonardo's search for a psychological interpretation of the human condition has found its fulfillment.

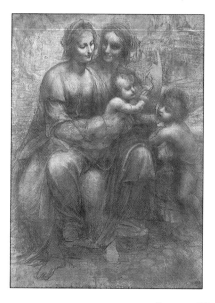

MONA LISA (LA GIOCONDA)

1503–1507; OIL ON PANEL;
30 ¼" × 20 ⅞" (76.8 × 53 CM);
LOUVRE, PARIS

The mysterious smile of the *Mona Lisa* has become
an icon of Western art. Leonardo's biographer
Giorgio Vasari was the first to name the sitter as
the wife of Francesco del Giocondo of Florence,
and the owner of the painting as King Francis I of
France. It remained in the French royal collections
until 1805, when it entered the Louvre. The indi-
vidual yet idealized features embody harmony and
tenderness. Even the landscape of rocks and water
in the background appear as fragile elements of
nature that evaporate in the mist.

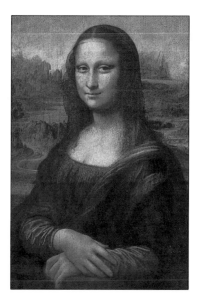

MONA LISA (DETAIL OF HEAD)

"The eyes had that lustre and watery sheen which is always seen in real life, and around them were those touches of red and the lashes which cannot be represented without the greatest subtlety....The nose, with its beautiful nostrils, rosy and tender, seemed to be alive. The opening of the mouth, united by the red of the lips to the flesh tones of the face, seemed not to be colored but to be living flesh." This vivid description by Vasari, who saw the painting in the sixteenth century without its layers of patina, might help us to look anew at the work despite its blinding familiarity.

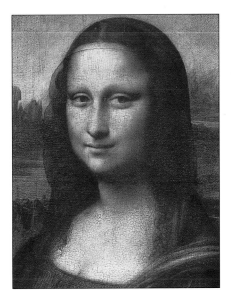

VIRGIN AND CHILD WITH ST. ANNE

CIRCA 1508–1510; OIL ON PANEL;
66 ³/₈″ × 51 ¼″ (168.6 × 130.2 CM);
LOUVRE, PARIS

This was Leonardo's final effort to deal with this subject. He most likely started this work after his return to Milan in 1508. As with many other projects the artist undertook, the painting remained unfinished. The Virgin's drapery has been only briefly outlined, and Leonardo's studio assistants apparently intervened. The landscape in the background, however, and the concept of the pyramidal structure of this composition are entirely Leonardo's. The lamb the Christ Child is holding signifies the Passion.

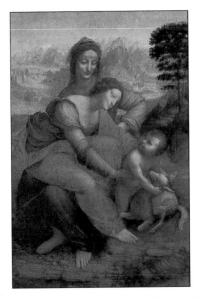

VIRGIN AND CHILD WITH ST. ANNE
(DETAIL OF ST. ANNE AND VIRGIN)

Leonardo solved the problem of grouping the figures more felicitously than in the earlier cartoon (see page 52). Here, communication between mother and daughter is continuous and reciprocal. Sigmund Freud, among others, noted that St. Anne seems only slightly older than her daughter, Mary. Freud interpreted this as a reflection of Leonardo's childhood fantasies since the illegitimate boy grew up with a stepmother. It seems more likely though that a contemporary theological discussion about St. Anne influenced this concept.

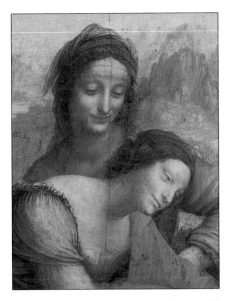

St. John the Baptist

CIRCA 1513–1516; OIL ON PANEL;
27 1/4" × 22 1/2" (69.2 × 57.2CM);
LOUVRE, PARIS

Leonardo's most significant innovation in this painting was to focus on the single figure, leaving everything around it in a neutral darkness. The other interesting qualities of this painting, however, are frequently overlooked. The figure's disturbing smile, his androgynous character, and his flaccid anatomy have often provoked a negative response. Nonetheless, his emotional vigor is irresistible. The uninhibited display of the saint's inner self and the mystical light reflected on his body are seminal features that were to become characteristic of works of art in the following century.

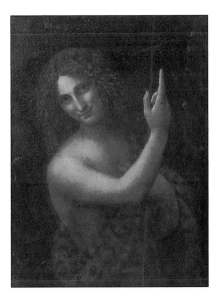

MADONNA WITH THE CARNATION

CIRCA 1475–1477; OIL ON POPLAR;
24 ½" × 18 ½" (62.2 × 47CM);
ALTE PINAKOTHEK, MUNICH

This is an early work that bears stylistic links to Leonardo's artistic training in the workshop of his master, Andrea del Verrocchio. Unfortunately, the heads of the Madonna and the Child have been repainted by a different hand, but the overall sensibility of the work can still be gathered from the gentle gesture between mother and child and from the elegant drapery of the dress. The flower in the Virgin's hand, a red carnation, is a symbol of Christ's passion.

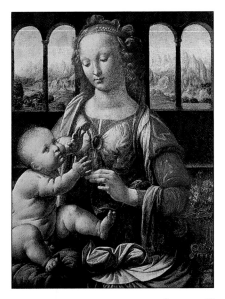

MADONNA LITTA

CIRCA 1490; TEMPERA ON CANVAS
(ORIGINALLY PANEL); 16 ½" × 13"
(41.9 × 33 CM); HERMITAGE, ST.
PETERSBURG

> Leonardo's authorship of this painting has been
> extensively debated. When this work is compared
> with other works by the artist, inconsistencies are
> apparent, especially in the head of Christ Child.
> Preparatory drawings, however, seem to indicate
> that at least the concept, if not part of the execu-
> tion, was Leonardo's. A definitive opinion is hard to
> reach since the work has suffered through several
> restorations.

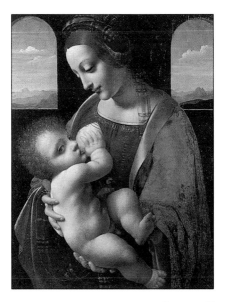

La Belle Ferroniere (Portrait of a Lady)

CIRCA 1490; OIL ON PANEL;
24 ½" × 17 ⅜" (62.2 × 44.1CM);
LOUVRE, PARIS

The sitter in this portrait has never been identified, and the title, a nickname of one of Henry II's mistresses, is due solely to a confusion in early inventories. The woman is posed in a way similar to Ginevra de' Benci and Mona Lisa (see pages 20 and 54), yet it does not evoke the same intense reaction in the viewer as those works do. The model's features are regular, almost static, and the carefully arranged necklace as well as the heraldic stiffness of the dress are quite uncharacteristic of Leonardo, whose authorship of this painting has not been universally accepted.

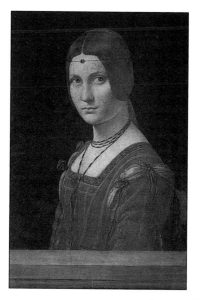

BATTLE OF ANGHIARI; ANONYMOUS (AFTER LEONARDO)
16TH CENTURY; OIL ON WOOD;
47 ½" × 28 ⅜" (121 × 72CM);
UFFIZI, FLORENCE

In 1503 Leonardo received a commission from the city council to paint a large fresco in the main hall of the Palazzo Vecchio, the administrative center of Florence. The subject chosen was the victory of the Florentines over the Pisans at the Battle of Anghiari. As with the *Last Supper* (see page 42), Leonardo's attempt to work with a special method on dry rather than wet plaster turned out to be unsuccessful. The remaining parts, considered by some to be among the most worthy works to be seen in that city, did not survive the general reconstruction of the room in 1565 and are known today only through early copies such as this one.

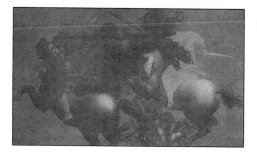

RIDER ON HORSEBACK
CIRCA 1503–1505; BRONZE; 5 ¾"
(14.5CM); MUSEUM OF FINE ARTS, BUDAPEST

In preparation for the *Battle of Anghiari* (see page 70), Leonardo studied the complex movements of horses and riders by making small wax models, as is suggested by a note written in the artist's hand next to a drawing, "make a little one [i.e., a model] of wax about four inches long." This bronze, probably executed by a studio assistant, reflects such efforts. During his artistic career Leonardo was twice involved in designs for equestrian monuments, but neither of them was ever realized.

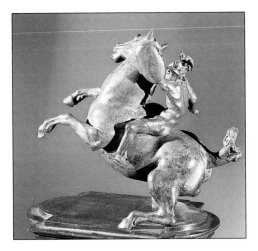

Drapery Study for a Seated Figure

CIRCA 1475–1480; BRUSH, IN GREY TEMPERA, HEIGHTENED WITH WHITE, ON GREY, PREPARED LINEN; 10 ½" × 10" (26.5 × 25.3 CM); LOUVRE, PARIS

The biographer Giorgio Vasari says that as a student Leonardo "often made figures in clay which he covered with a soft worn linen dipped in clay, and then set himself to draw them with great patience on a particular kind of fine Rheims cloth or prepared linen; and he executed some of them in black and white with the point of a brush...." This painting is one of these studies, which help us to appreciate the particular character of Leonardo's early draperies and his meticulous search for an understanding of form.

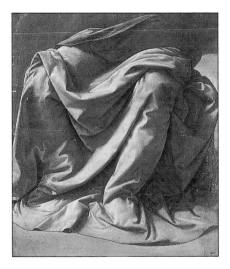

PROFILE OF A WARRIOR WITH HELMET

CIRCA 1480; SILVER-POINT ON PREPARED
CREAM-COLORED PAPER, 11 $\frac{1}{4}$" × 8 $\frac{1}{8}$"
(28.5 × 20.7CM); BRITISH MUSEUM,
LONDON

This well-known drawing shows the influence of Leonardo's master, Andrea del Verrocchio—and the ability of his student to surpass him. The man's severe expression and the meticulous rendering of details in the helmet and armor are impressive. It is not known whether this drawing was done in preparation for another work, although it is highly finished. Leonardo used a silverstick as a drawing utensil, which does not allow rapid execution. On paper that is previously prepared with a chalky substance the stylus leaves dark traces of oxidized silver.

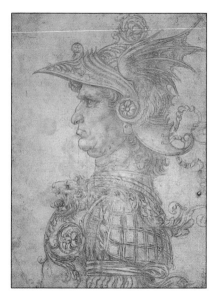

PROFILE OF A MAN AND STUDY OF HORSEMEN

CIRCA 1490 AND CIRCA 1503–1504;
PEN AND INK AND RED CHALK;
11" × 8 ¾" (27.9 × 22.3 CM);
GALLERIA DELL'ACCADEMIA, VENICE

Leonardo frequently reused old sheets of paper and did not hesitate to draw or write over existing sketches. In this case the horsemen were probably done in connection with the *Battle of Anghiari* (see page 70), which dates from 1503–1504, while the proportion study of the man in profile dates from around 1490. The text to the left was written in reverse, as was customary for Leonardo, who possibly wanted to keep his notes secret. This profile relates to the artist's efforts to examine the rules of proportion of the human body.

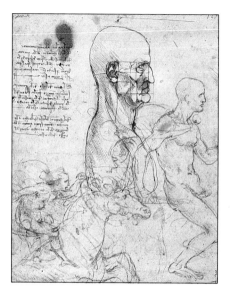

STUDY OF HUMAN PROPORTIONS (VITRUVIAN MAN)

CIRCA 1490; PEN AND BROWN INK, WASH AND RED CHALK ON PAPER; 13 ½" × 9 ⅝" (34.3 × 24.6 CM); GALLERIA DELL'ACCADEMIA, VENICE

After his year-long studies on the proportion of the human body, Leonardo drew this exceptional sheet following the prescription of the Roman architect Vitruvius: "In the human body the central point is naturally the navel. For if a man be placed flat on his back with his hands and feet extended, and a pair of compasses centered on his navel, the fingers and toes of his hands and feet will touch the circumference of a circle described therefrom. And just as the human body yields a circular outline, so too a square figure may be found from it."

DRAWING OF A FLYING MACHINE WITH A MAN OPERATING IT

CCIRA 1488–1489; PEN AND INK;
9" × 6" (23 × 16 CM); MS. B,
BIBLIOTHÈQUE DE L'INSTITUT DE FRANCE, PARIS

This and the following drawing (see page 84) are part of a manuscript collection known as "Manuscript B" to distinguish it from other groups. Here Leonardo studied the problems of artificial flight, of which he made thirteen studies in total. This drawing shows a man at work generating the power for a machine that somewhat resembles a modern helicopter. Leonardo later realized the inadequacy of the device, but this early study is visually more attractive than the more scientifically accurate drawings of a later date.

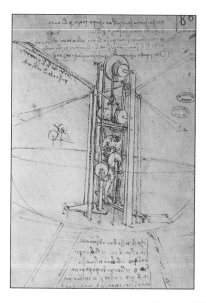

PLANS AND PERSPECTIVE VIEWS OF DOMED CHURCHES

CIRCA 1490; PEN AND INK;
9" × 6 ½" (22.8 × 16.5CM); MS. B,
BIBLIOTHÈQUE DE L'INSTITUT DE FRANCE, PARIS

Leonardo was also esteemed as an architect. In a series of drawings he developed various solutions for one of the most notorious architectural problems of the Renaissance, namely the construction of a domed, centrally planned church. Although never intended to be built, Leonardo's structures influenced a number of Renaissance architects, in particular Donato Bramante, who was later responsible for the building of St. Peter's in Rome.

ST. PETER

CIRCA 1495; PEN AND INK OVER METALPOINT
ON BLUE PREPARED PAPER; 5 ¾″ × 4 ½″
(14.6 × 11.4CM); GRAPHISCHE SAMMLUNG
ALBERTINA, VIENNA

This drawing is considered to be a first study of St.
Peter for the *Last Supper* (see page 42). Leonardo
seems to have taken up anew an older drawing
technique, metalpoint on blue paper, which he had
already abandoned before arriving in Milan. In the
Last Supper, the apostle (third figure from the left)
appears in a similar pose with almost the same
characteristic beard. The most striking difference is
the position of the hands, which have assumed the
symbolic gesture of repulse.

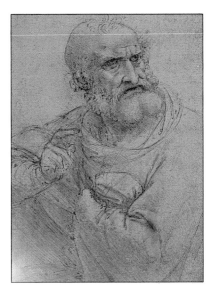

Portrait of Isabella d'Este

1500; Black Chalk with charcoal and pastel; 24" × 18 ⅛" (61.1 × 46cm); Louvre, Paris

Upon the arrival of the French troops in 1499, Leonardo left Milan and went to Mantua, where he drew a portrait of Isabella d'Este (1474–1539), an impressive noblewoman and patron of the arts. She is shown seated, in profile, with her arms folded in front of her, and wearing a wide-necked dress. It is curious that Leonardo chose to represent her this way, as it does not require any movement into depth. After Leonardo returned to Florence, Isabella attempted to commission paintings from him, but there is no evidence that she met with any success.

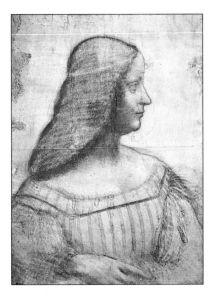

PLAN OF IMOLA

1502; PEN AND INK AND WATERCOLOR;
17 1/4" × 23 3/4" (44 × 60.2 CM)
ROYAL LIBRARY, WINDSOR CASTLE

Leonardo's work as a cartographer forms a distinct portion of his artistic output. His maps are more than historical renderings; they are closer to landscapes. Cesare Borgia, the famous Renaissance captain and son of Pope Alexander VI, employed Leonardo temporarily as a military engineer. Leonardo must have drawn this plan in October of 1502 while Cesare Borgia was immobilized in the town of Imola in Northern Italy during a rebellion of some of his troops. This is one of the earliest geometric town plans ever, a departure from the traditional bird's-eye views of towns so common until the end of the sixteenth century.

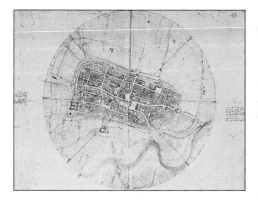

DISSECTION OF THE PRINCIPAL ORGANS AND ARTERIAL SYSTEM OF A WOMAN

CIRCA 1500; PEN AND INK OVER BLACK CHALK; 18 ½" × 12 ⅞" (47 × 32.8 CM); ROYAL LIBRARY, WINDSOR CASTLE

The study of the human body, which occupied Leonardo over many years, sprang from his idea of painting as a science. Driven by a noble and passionate curiosity, he carried his research far beyond the needs of painting, venturing into the field of scientific anatomy. Leonardo even attended nightly sessions of medical dissections, during which he took notes and made sketches in order to record his observations. Although not accurate by today's standards, his insight and understanding of human anatomy is still astonishing.

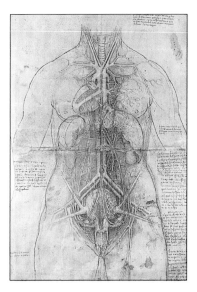

Index of Artworks

PHOTOGRAPHY CREDITS

Alinari/Art Resource, New York p. 27
Art Resource, New York pp. 39, 41, 53, 87, 93
Bridgeman/Art Resource, New York p. 77
Giraudon/Art Resource, New York p. 83
Erich Lessing/Art Resource, New York, front jacket, pp. 15,
 17, 19, 33, 35, 37, 49, 51, 55, 57, 59, 61, 63, 69, 73
© 1993 National Gallery of Art, Washington, D.C.,
 Ailsa Mellon Bruce Fund pp. 21,23
Nimatallah/Art Resource, New York p. 4
Scala/Art Resource, New York pp. 9, 11, 13, 25, 27, 29,
 31, 43, 45, 47, 65, 67, 71, 75, 79, 81, 85, 89, 91

A THOMAS NELSON BOOK

First published in 1993 by Thomas Nelson Publishers, Nashville, Tennessee.

Copyright © 1993 by Magnolia Editions Limited

10 9 8 7 6 5 4 3 2 1

Library of Congress Cataloguing in Publication Data is available.

Library of Congress Card
93-83507

ISBN 0-7852-8308-0

MINIATURE ART MASTERS
GREAT EUROPEAN ARTISTS: DA VINCI
was prepared and produced by
Magnolia Editions Limited,
15 West 26th Street, New York, N.Y. 10010

Editor: Sharyn Rosart
Art Director: Jeff Batzli
Designer: Susan Livingston
Photography Editor: Ede Rothaus

Printed in Hong Kong and bound in China